CELTS

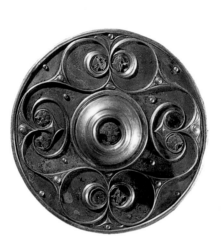

THE BRITISH MUSEUM

LITTLE BOOK OF
CELTS

Celts or Gauls are the names that Greek and Latin writers gave to the barbarian tribes whose homeland was north of the Alps. Doubtless the Celts regarded themselves as unrelated and independent tribes; if they gave themselves an overall name then it is unknown. Archaeologically there is an element of unity in the Iron Age remains from the British Isles across France, Switzerland, southern Germany to Hungary and Romania. Graves and settlement sites produce related forms of ornaments, weapons, pottery and especially a distinctive style of art. Classified by archaeologists as the La Tène culture, loosely correlated with the Celts, these material remains belong to the last four to five centuries BC, ending as the legions advanced from Rome. But the Romans never reached Ireland, where an independent La Tène culture survived.

Only the Celtic peoples on the Atlantic edge of the Roman Empire and beyond, in west and north Britain and Ireland, retained their ancient language and traditions when the

western empire collapsed. The pelta and spiral designs in early medieval Celtic art show their origins in the European La Tène culture, but these were used on new objects, dress fasteners and vessels. In Ireland the early acceptance of Christianity with its Latin book-learning produced brilliant art and scholarship when the rest of Europe was contending with the effects of Germanic invasions. By the eighth century Irish smiths were making the finest metalwork in Europe in a distinctive style drawing on Celtic, Germanic and Christian traditions. After the disruptions of Viking raids fine metalwork was again produced in a typical Irish-Norse style in the eleventh and twelfth centuries.

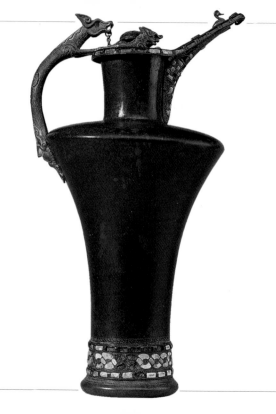

BASSE-YUTZ FLAGON

*c.*400 BC

This bronze flagon, decorated with coral and red enamel, provides the ideal introduction to early Celtic art, belonging to an early stage in its development and including elements from its three main components. First, a marked classical strand, represented especially by the palmette motif on the throat of the flagon; second, an oriental influence witnessed by the dogs or wolves on the handle and rim; and third, a native component neatly epitomised by the duck (a popular European Iron Age motif) on the spout. Within a very short time, in the second half of the fifth century BC, these diverse influences were borrowed, modified and integrated to form one of the outstanding art styles of the ancient world. One of a virtually identical pair, the flagon comes from Lorraine, France.

SOMME-BIONNE HARNESS-DISC

c.400 BC

O ne of the most important centres of the La Tène culture is in Champagne, where the Iron Age peoples buried their dead with a wealth of grave-goods. The most impressive type of grave there is the cart-burial, and one of the very few to survive the ancient grave-robbers was excavated at Somme-Bionne in 1873. The skeleton, buried on the floor of a two-wheeled vehicle, was wearing a belt and was accompanied by a sword in its decorated scabbard, a knife, a set of iron skewers, a bronze Etruscan flagon, a Greek painted cup, and a large native pot. The metal fittings of the vehicle survived, along with a fine collection of decorated harness, including the perforated disc illustrated here.

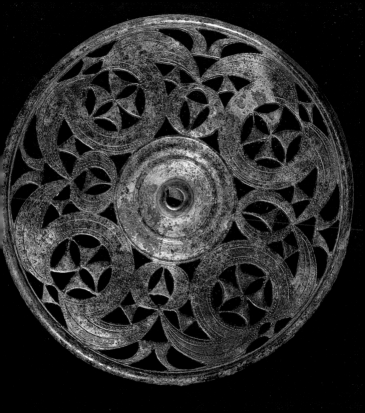

Prunay Vase

4th Century BC

This magnificent painted pedestalled urn came from another grave in Champagne. Its burnished surface is decorated in reserved red against a black background, with a continuous wave-tendril with prominent lobes alternating above and below. Such flowing tendril designs were popular throughout the Celtic world in the fourth century BC and into the third century BC. Grave-digging became popular in Champagne in the second half of the nineteenth century, and it has been estimated that more than 12,000 La Tène graves were excavated, but few were recorded. The finds were acquired by collectors, and one of the foremost was Léon Morel, whose collection was acquired by the British Museum in 1901.

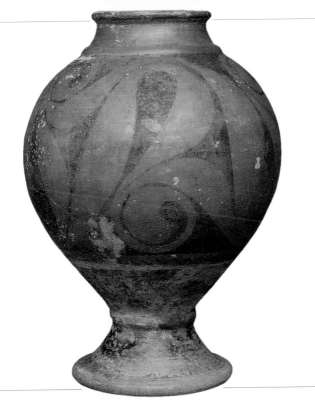

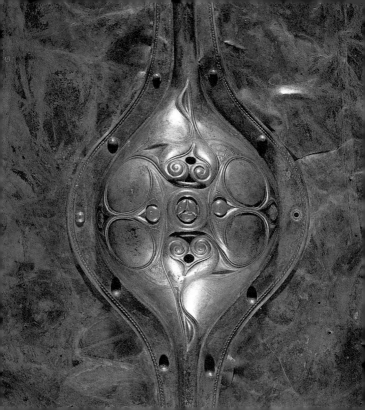

B ritish Celtic art closely followed the continental tradition in the fourth century BC, but in the third century it developed distinctive styles of its own, and masterpieces were created that are unsurpassed in Europe. One such is the shield, in fact the bronze facing of a now lost wooden shield, found in the River Witham at Washingborough, Lincolnshire in 1826. It is a long (1.13 m) oval shield whose wooden backing would have had a central hand-hole crossed by the handle. The bronze boss is fashioned in one piece with the central spine and two terminal discs, and elaborately decorated in repoussé and engraving with applied highlights of imported coral.

DECORATED LINCH-PINS

Cart-burial is a rite shared by La Tène cultures in several parts of Europe, including one British group in Yorkshire. The two-wheeled vehicles are found in the graves of both men and women, so they should be regarded as a general form of transport rather than as, say, a war-chariot. In a burial at Kirkburn, excavated in 1987, the cart had been dismantled and the two wheels were flat on the floor of the grave with harness and vehicle fittings, including the pair of linch-pins illustrated here. The linch-pins (length 120 mm), intended to secure the wheels to the axle of the vehicle, have iron shanks with bronze terminals decorated in relief with triskele designs.

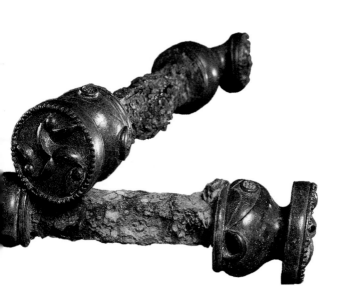

BATTERSEA SHIELD

(?) 4TH TO 2ND CENTURY BC

The bronze remains that would have faced a wooden shield comprise three decorated panels, four background sheets and the binding. The more or less symmetrical design has been executed in repoussé in high relief by an extremely accomplished craftsman. But there are few close parallels for his work, which stands apart from the mainstream development of Celtic art in Britain, and it cannot be dated closely. Like many other fine pieces of Iron Age metalwork, the Battersea shield was found in the River Thames. It seems more likely to have been ceremonial than functional, and was probably consigned to the water in order to thank or appease the gods.

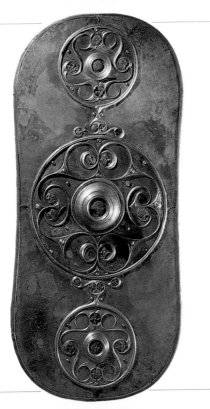

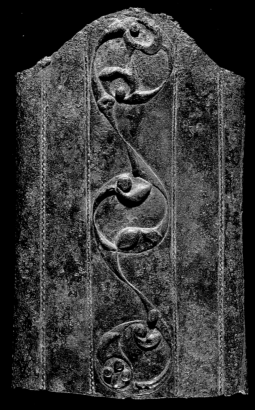

BRONZE SCABBARD-ORNAMENT

c.200 BC

In southern Britain Iron Age cemeteries are rare before the end of the first century BC, but one exception is a site at Mill Hill, Deal, Kent. Most of the burials there were poorly equipped, but one relatively rich grave has produced more examples of Celtic art than any other in Britain. Buried in a shallow grave was the skeleton of a young man accompanied by a sword in a scabbard with bronze fittings, including the decorated plate illustrated here; two bronze strap-fittings and a brooch, all with coral attachments; and the remains of a shield. On his head he wore a unique decorated crown.

LATE 2ND CENTURY TO EARLY 1ST CENTURY BC

Some of the earliest coins to circulate in Britain belong to the Gallo-Belgic series, found in south-east Britain and in north-west Gaul. How they arrived here is debatable, with different scholars favouring trading contacts, payment to mercenaries, and introduction by invading tribes. The prototype for the series is the gold stater of Philip II of Macedon, which has a portrait of Apollo on the

obverse and a chariot drawn by two horses on the reverse. The Celts modified and stylised the design: on the illustrated coin the face is dominated by the hair and laurel wreath, and the chariot scene reduced to a single horse with a charioteer floating above it. (Approximate diameter 35 mm.)

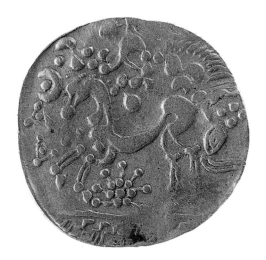

In a field at Snettisham, in north-west Norfolk, at least 13 hoards of gold and silver, torques (neck-rings), ingots and coins, have been found. Most of them seem to have been buried between 100 and 50 BC, and they may well represent a tribal treasury. The finest piece, disturbed by ploughing in 1950, is known as the Great Torque and would have been fit for royalty, or even a god. Eight strands, each composed of eight twisted wires, have been shaped round a hollow core and provided with hollow cast-on terminals. Elaborately decorated with relief lobes, the terminals would have been shaped and decorated in wax before being cast in a gold-silver alloy.

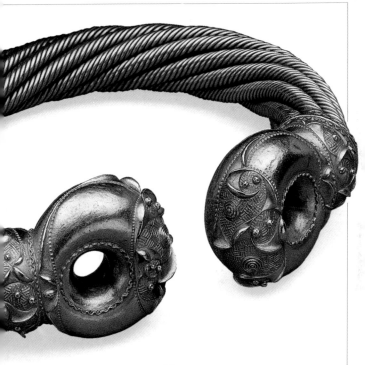

DECORATED SPEARHEAD

2ND OR 1ST CENTURY BC

Spears figure prominently in historical descriptions of the Celts in battle. Indeed, in Caesar's account of his expeditions to Britain in the middle of the first century BC they are the only weapons that he mentions. The finest Iron Age spearhead from Britain, found in the River Thames at London, has on each side a shaped piece of bronze riveted to each wing and decorated with a chased design. The four shapes and their ornaments are all slightly different. This unique piece was perhaps the head of a chieftain's ceremonial spear.

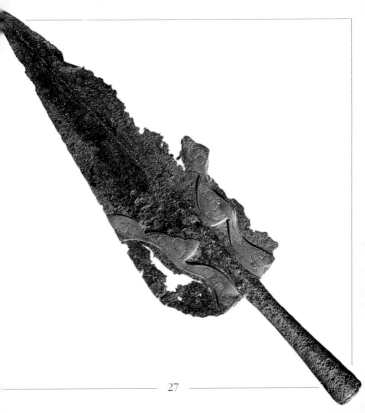

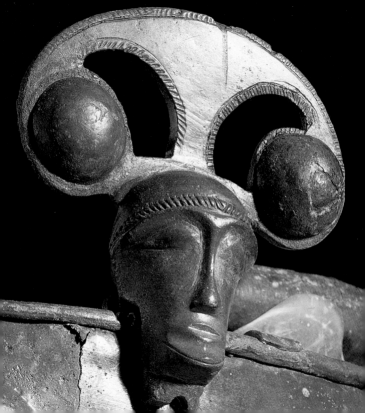

DECORATIVE HEAD FROM BRONZE-BOUND
WOODEN BUCKET
SECOND HALF OF THE 1ST CENTURY BC

During the first century BC cremation was adopted as the standard burial rite in south-eastern Britain, and several cemeteries are known. The Aylesford cemetery in Kent was one of the earliest to be discovered, in 1888, and its most spectacular burial included a stave-built wooden bucket bound in bronze. The severe helmeted heads retaining the ends of the swing-handle are among the very few representations of a Briton. The Aylesford bucket was found with three brooches, several pots and two bronze vessels imported from Italy or southern Gaul, a flagon and a pan. Wooden buckets would have been a common feature of Iron Age life, but the wood itself has usually perished long ago and only the metal fittings survive.

Before Britain was conquered Roman fashions were already being adopted in the south-east. This is illustrated by a richly furnished burial found at Welwyn Garden City, Hertfordshire in 1965. Along one side of the grave were six imported Italian amphorae which would have held 25 gallons of wine; there were 36 other pots, including flagons, platters and cups; wooden vessels represented only by metal fittings; a bronze dish and the bronze vessel for straining the wine, as well as the Italian silver cup for drinking it. But the most remarkable find was a complete set of glass game-pieces: 24 pieces divided by colour into four sets of six (one of each colour is illustrated). Unique and probably imported from the Eastern Mediterranean region, they would have been used for a race-game, akin to ludo.

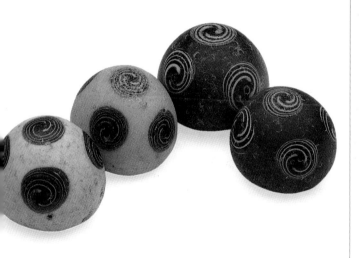

BRONZE HELMET

Metal helmets are occasionally found on the Continent, and classical writers refer to some with elaborate fittings, including horns. Horned helmets are also known from representations, but the only one to survive is this example found in the River Thames before 1866. Shaped from thin bronze, it has two short conical horns, and at the time of its discovery it was regarded as a jester's cap. Its decoration is elaborate: a meandering assymmetric design with repoussé lobes and studs that have been keyed to take red glass ornaments. If helmets were worn in battle then they are likely to have been leather, and would have perished long ago. The Thames helmet was doubtless a ceremonial piece.

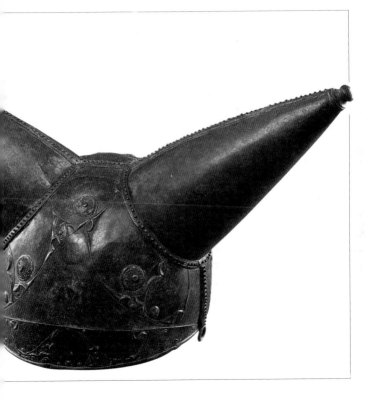

BRONZE MIRROR

1st CENTURY BC

Bronze mirrors from as early as the fifth century BC have been found on the Continent, but they are not common. In Britain iron mirrors were in use from the third century BC, and four have been found in graves in Yorkshire. But the finest Iron Age mirrors are those used in the south of England in the first century BC. Made of bronze, one side was polished to provide the reflecting surface, and the other ornamented with chased and engraved designs. This mirror, from Desborough, Northamptonshire, is elaborately decorated with almost symmetrical tendrils, infilled with basketry hatching. Most of the decorated mirrors have been found in graves, and where the human remains could be sexed they were female graves.

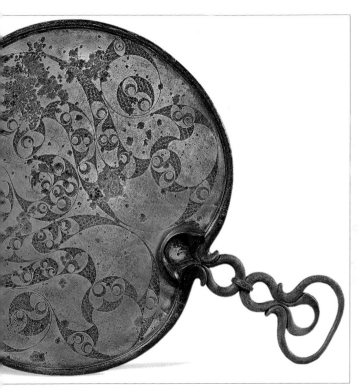

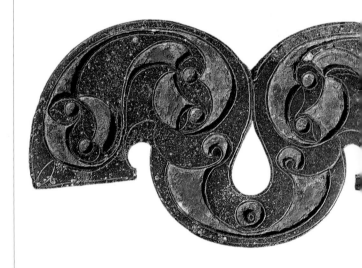

This elaborate bronze plaque and other harness fittings, including horse-bits and rein-rings, were found before 1803 somewhere in the Polden Hills, Somerset. The hoard included a brooch that enables it to be dated to 10 or 20 years after the Roman Conquest, but the harness is all in the native tradition. The design on the illustrated piece is more or less symmetrical, and it would have been worked in a wax model before being encased in clay to form a mould and then cast in bronze. The red enamel has been applied by the champlevé technique, set in a shallow sunken field and then fused in an oven. Britain was famous for its enamel-work, and harness mounts of various shapes were decorated especially in red, but also in yellow and blue.

This doleful-looking horse-head is only small (101 mm high), and it has been shaped from a piece of sheet-bronze by the repoussé technique. The face is constructed from abstract trumpet-motifs, a common device in Celtic art. Its purpose is unknown, but it was obviously intended to be nailed to a wooden base. Found in a hoard with a lot of harness and vehicle fittings, it may have been intended to decorate a vehicle. The hoard was discovered at Stanwick, North Yorkshire before 1845, within an enormous defended enclosure which saw a great deal of activity in the second half of the first century AD. It must have been a major centre of resistance for the tribe of the Brigantes, as the Romans pushed north into Scotland in the 70s AD.

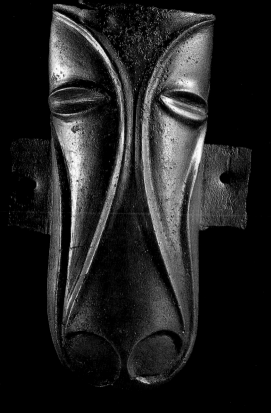

DRAGONESQUE BROOCH

c. AD 100

During four centuries of Roman rule Britain enjoyed and produced Roman art, but Celtic traditions survived among local craftsmen. The origins of the Dragonesque brooch go back to the second century BC, but it was popular after the Roman Conquest despite competing with brooches standardised across the Empire. This one is unprovenanced, but most are from northern England and southern Scotland. Stylised animal heads, enamel and compass-based abstract patterns are Celtic traits used also by craftsmen both in Ireland and in Britain in the centuries after Roman rule.

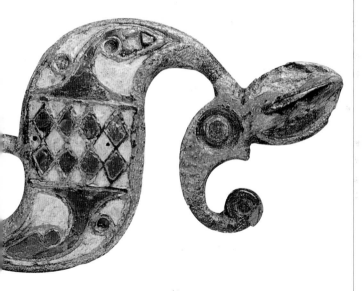

6TH TO 7TH CENTURY AD

This strange bronze, richly inlaid with enamel, is a dress fastener of an unusual type found only in Ireland in the sixth to seventh centuries. It is known as a 'latchet' from its distinctive shape. It was attached by wires wound in a spiral round the narrow arms and which were themselves twisted through the cloth of a garment to hold the fastening in place. Only about ten are known and they vary from large and undecorated to highly decorated forms like this one from Dowris, County Offaly, which has the fine spirals and contrasting grid pattern typical of Celtic metalwork of this period. The latchet was supplanted by the ubiquitous but possibly more practical brooch or pin.

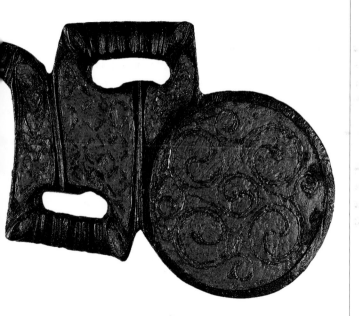

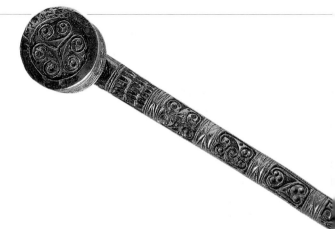

DISC-HEADED PIN

(?) 6TH CENTURY AD

This massive silver pin, 32.4 cm long, was a dramatic statement of the importance of its wearer. Originally all the finely incised ornamental panels were inlaid with bright red enamel contrasting with the delicate peltas, dots and spirals. Each panel is framed with tiny punches and saltires. These motifs are very close to those found on earlier Celtic metalwork and the pin was probably made in the sixth century. Unprovenanced, it comes from a predominantly Irish collection and is very similar to another fine pin found in Ireland, which is probably where they were both made and certainly where such pins were worn. There is also a connection with contemporary Pictish silverwork.

RECTANGULAR MOUNT FROM SUTTON HOO HANGING BOWL

6TH OR EARLY 7TH CENTURY AD

This is one of eight magnificent enamelled mounts used to embellish a bronze bowl both inside and out. The bowl was designed to be hung from three of these mounts, circular panels with hooked frames. Hanging bowls were made by Celtic smiths working in Britain and Ireland from the sixth century onwards. They attracted the attention of colonising Anglo-Saxons and this magnificent example was the largest one of three buried in a royal grave at Sutton Hoo, Suffolk in the 630s. The stylised animal heads in the spirals, the millefiori and pale-green enamel inlays and the division of ornament into separate panels show the latest stylistic and technical developments in the local Celtic decorative tradition shortly before it was replaced by a new, eclectic 'Insular' style

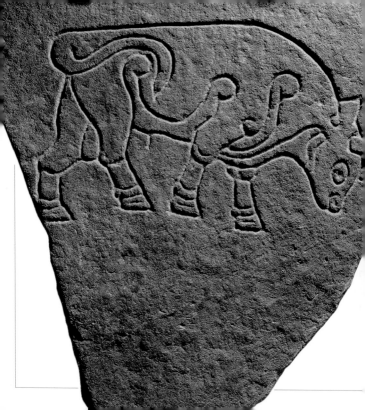

The beautiful sinuous curves of this bull are stylised and yet convey the massive presence of the beast. It is one of about ten found near a subterranean well in a Pictish stronghold on the coast of Morayshire, Scotland. These enigmatic Celtic peoples carved on slabs figurative and abstract shapes whose meaning has tantalised scholars. Did they indicate family groups, ancestral forces or individual names? On later monuments these symbols were combined with Christian themes. Some, like this fine bull, are found only in one area, others occur throughout the Pictish lands of north Britain. The spiral treatment of the joints links this style closely to the first Insular decorated Gospel books and indicates a date in the seventh century.

Both men and women wore brooches such as these to fasten outer garments. The bronze brooch on the left, from County Cavan, is typical of the bold open-ring (or penannular) brooches of the late sixth or first half of the seventh century AD in Ireland. It is inlaid with red enamel and millefiori glass, and has a simple incised decoration on the back. Its surface may originally have been made silvery by tinning. The brooch on the right is the finest in the British Museum's

medieval Celtic collection. This silver-gilt piece is set with amber and embellished with panels of interlace and animals; inset in the back are two discs of spiral ornament. Rich enough to have belonged to a king or to a church treasury, its history is unknown beyond inclusion in Lord Londesborough's Irish collection. The gilded surface with panels in varied styles is typical of the new Insular style which was well established by the eighth century. This brooch is unusual in having a domed circular boss on each terminal, bosses that seem to mirror in their detail much larger shrine mounts. It dates from the mid to late eighth century.

DRINKING-HORN TERMINAL

8TH CENTURY AD

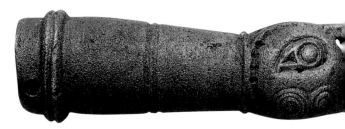

Although now toothless and much worn, this handsome beast (length 90 mm) was used to protect the end of a drinking horn which would have been passed to the noble guests by the wife or daughter of one of the high grades in Irish society. Hospitality was an important duty and helped bind the different groups together, although the liberal provision of mead and even wine could also lead to less than diplomatic behaviour. The type was originally copied from Germanic horn mounts, but this example, found at Lismore,

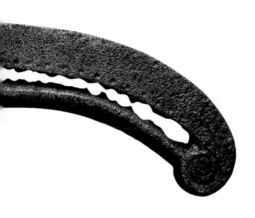

County Waterford, shows its Celtic pedigree with the
fine spirals decorating the tip and cheeks. It dates
from the eighth century.

STEEPLE BUMPSTEAD BOSS

8TH CENTURY AD

Made of gilded bronze and originally inlaid with many amber or glass studs as well as a band of niello and plates of filigree on the top, this was once part of a magnificent shrine on which five such bosses would have outlined a cross shape. The style and quality of all the cast ornament, from the four lions on the sides to the panels of triskeles and interlaced animals, all indicate the highest quality of Irish work of the eighth century. How it came to be used as a handle-plate on a church door in Essex can only be guessed at, but despite its battered state it is one of the treasures of the collection.

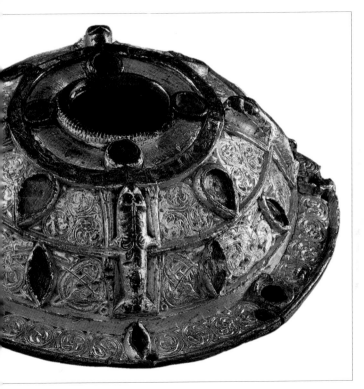

The core of this crozier is a wooden staff that was probably venerated as a relic of a monastic founder from the age of saints. The wood has been enshrined in bronze casings with rich decoration and repaired and further embellished with the passing of time. The present twelfth-century silver crook covered an earlier bronze one; the angular 'drop' at the end is typical of Irish croziers but dates in part from the late Middle Ages, while the first knob on the staff is a magnificent piece in Irish-Scandinavian Ringerike style inlaid with silver and niello. An inscription records the names of Conduilig and Melfinnen, and through this the crozier was, wrongly, associated with the great monastery at Kells. The crozier was found without explanation in a solicitor's cupboard in London in 1850.

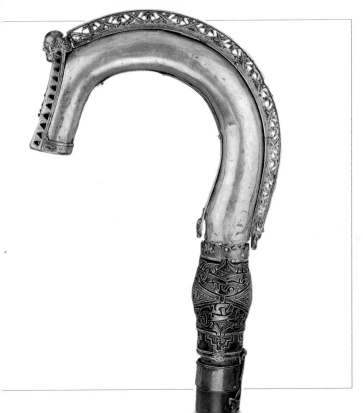

GLANKEEN BELLSHRINE

EARLY 12TH CENTURY AD

The intricately embellished bronze cover protects an ancient iron bell associated with St Cuilean of Glankeen, County Tipperary. Like many Irish bells treasured for their association with holy men, this one was kept by local families who inherited the duty of guarding it. The enshrinement dates to the early twelfth century and shows the ferocious stylised beast-heads in late Irish-Scandinavian Ringerike style, all lavishly inlaid with niello, enamels and combined copper-and-silver wires. The two human heads may represent Evangelists. The shrine once had a jewelled cross on the front, lost during the bell's chequered history before it came to the Museum in the mid-nineteenth century.

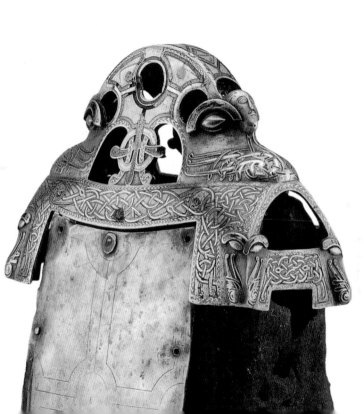

ACCESSION NUMBERS OF OBJECTS ILLUSTRATED

First published in 1996 by The British Museum Press
A division of The British Museum Company Ltd
38 Russell Square, London WC1B 3QQ

Paperback edition 2004
Reprinted 2009, 2012

A catalogue record for this book is available from the British Library

ISBN 978-0-7141-5028-4

Text by Ian Stead and Susan Youngs
Photography by the British Museum Photographic Service
Designed by Butterworth Design
Cover design by Harry Green

Typeset in Garamond
Printed in China
by Hing Yip Printing Ltd